sailing on a sunny day

Paris

free soap at
the hotel

sitting
by a
river

small hilltop villages

a staring competition
with a llama

capturing the
moment

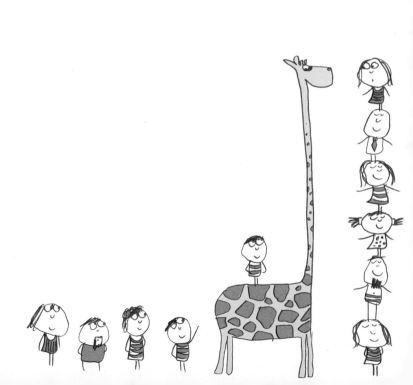

learning a new
language

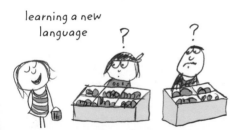

true French
croissants

cobblestone streets

a Turkish bath

the top deck of a
double-decker bus

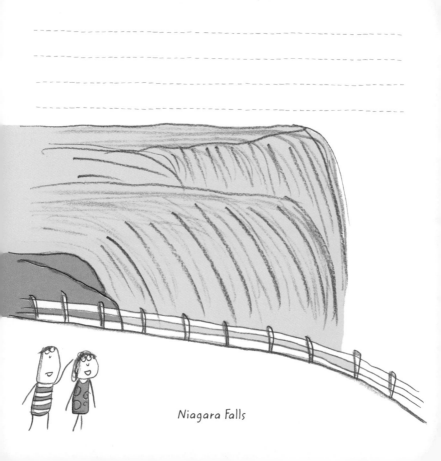

Niagara Falls

the perfect playlist
for a long bus trip

alone time in nature

swimming with
dolphins

jumping on a hotel bed

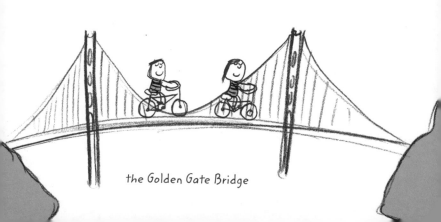
the Golden Gate Bridge

souvenir shopping

pyramids

celebrating new
adventures

arriving, finally

the Alps

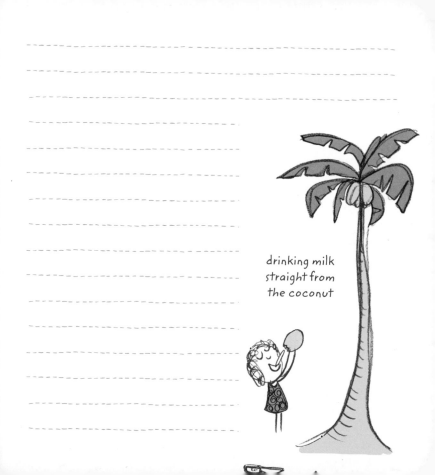

drinking milk
straight from
the coconut

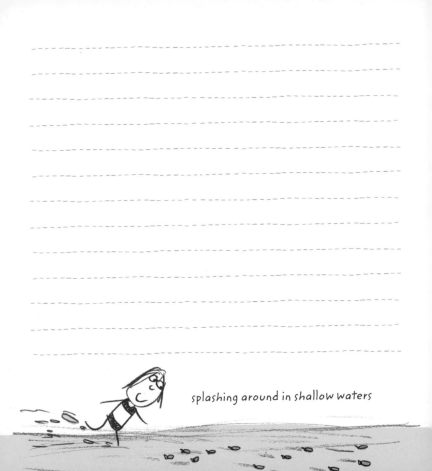

splashing around in shallow waters

falling in love with the country you are visiting

crêpes made to order

*returning to a place you loved as a
child and finding it unchanged*

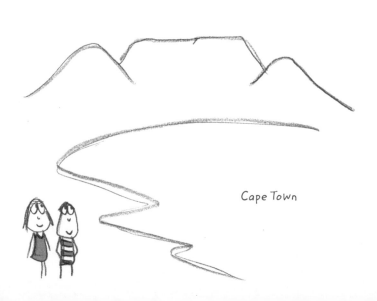

Cape Town

time to relax

the Confucian Temple

seeing
the world
through
a camera
lens

packing for an amazing
trip together

a "statue"
street
performer

planning a trip

banana
trees

margaritas on the beach

backpacking
together

a deserted island

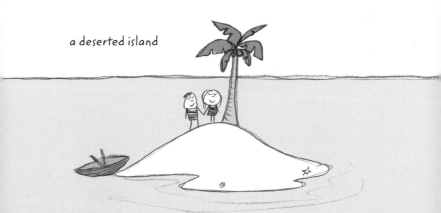

the sounds of nature

the Taj Mahal

a fresh baguette

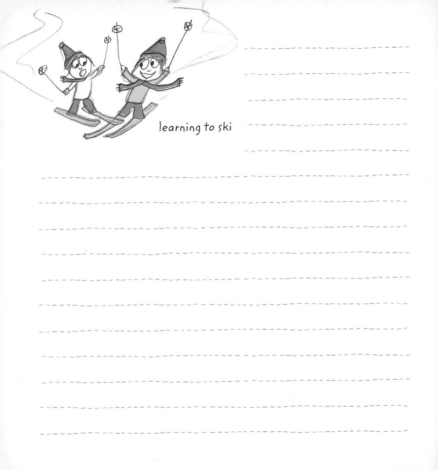

learning to ski

finding new destinations

getting into the
traveling groove

exploring
at dawn

the
Empire
State
Building

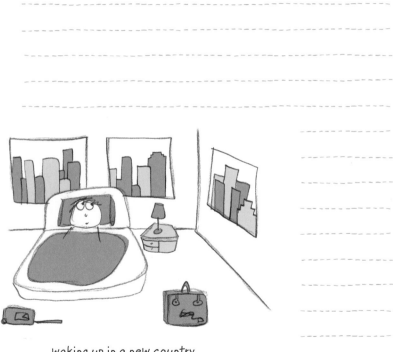

waking up in a new country

going on safari

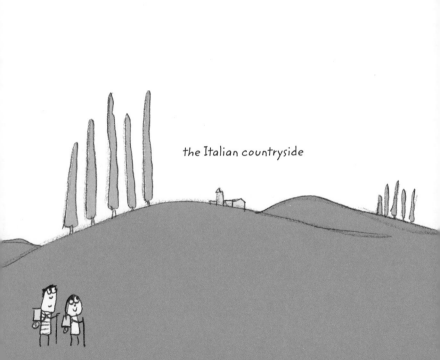

the Italian countryside

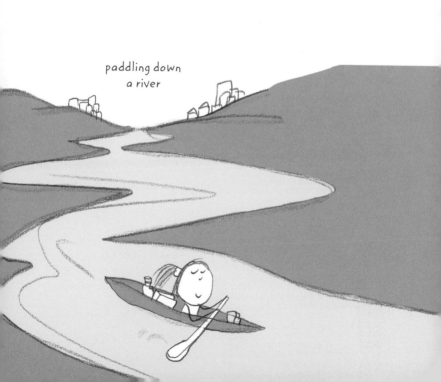

paddling down
a river

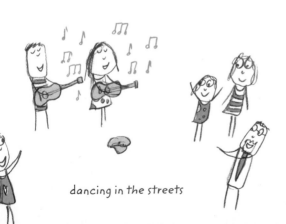

dancing in the streets

street food

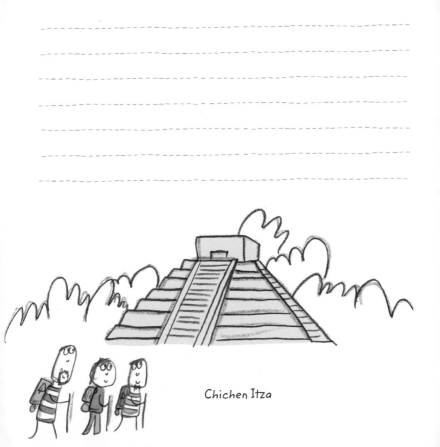

Chichen Itza

jogging in a city that you love

Africa

sharing a snack on top of a mountain

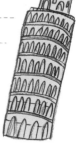

the leaning
tower of Pisa

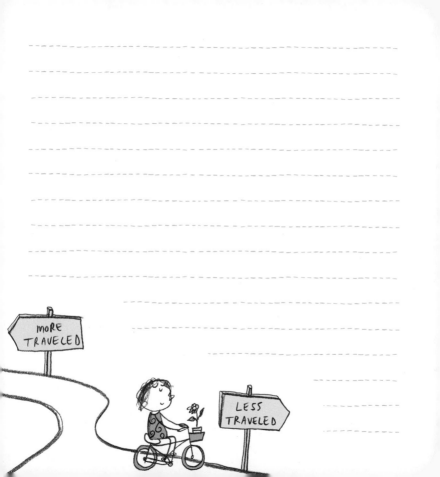

MORE TRAVELED

LESS TRAVELED

a carload of friends and the empty road

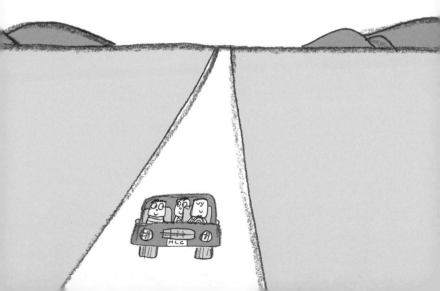

camping trips

planning
tomorrow's
adventures

getting a window seat

a different perspective

the last ten miles

chilling with penguins

eating with your hands

sitting next to someone nice on the plane

checking in at
the airport

traveling with a friend

a gorgeous
view from your
balcony

fresh snow

a beautiful hike
in unfamiliar
mountains

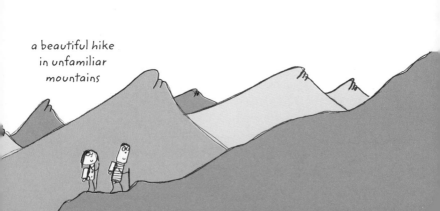

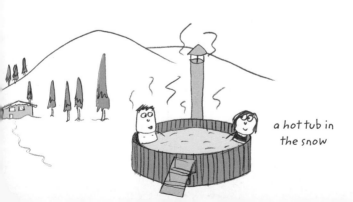

a hot tub in
the snow

Big Ben

friends who love to travel

a lazy beach vacation

a one-way ticket

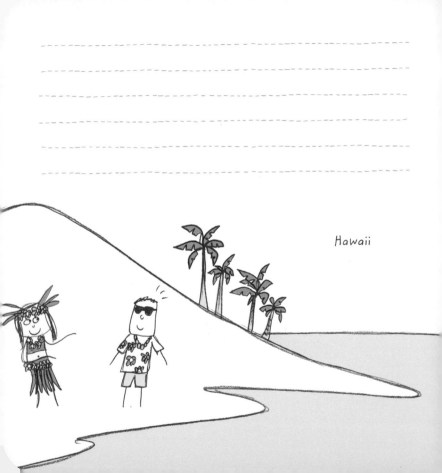

Hawaii

exploring
famous
museums

mapping the voyage

enjoying the journey

a sunrise fishing trip

watching the world go by

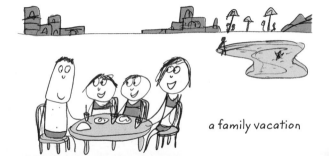

a family vacation

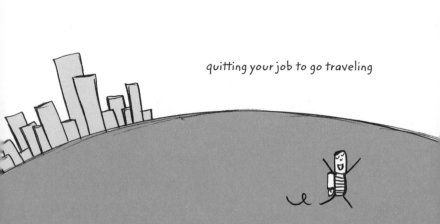

quitting your job to go traveling

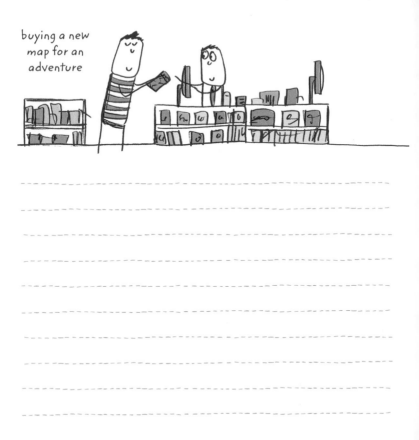

buying a new
map for an
adventure

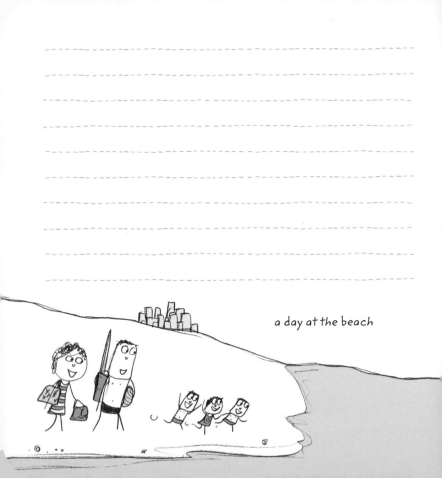

a day at the beach

vacation indulgences

a jetty on a lake

exploring the world

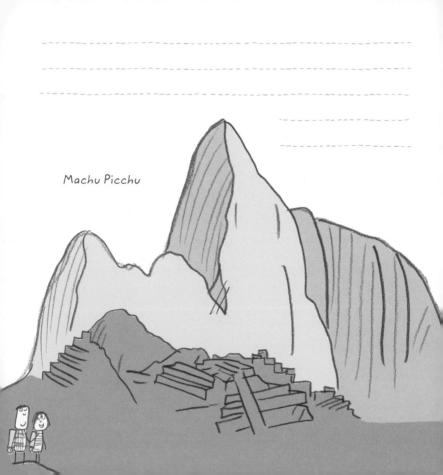

Machu Picchu

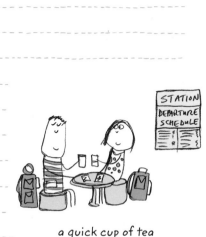

a quick cup of tea
before the train departs

boating down a river

the Sydney Opera House

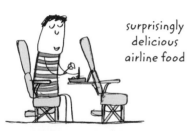

surprisingly
delicious
airline food

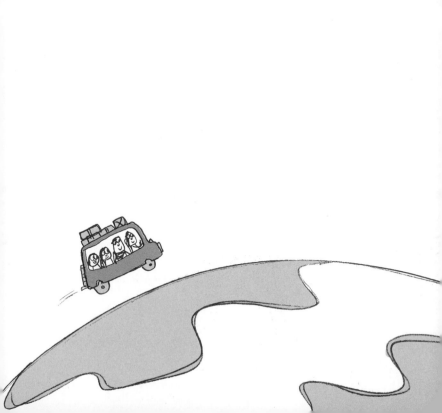

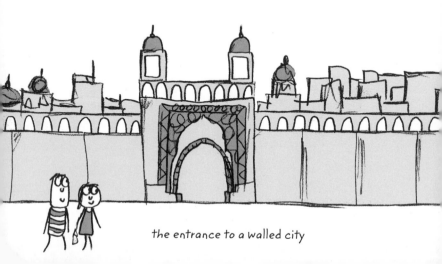

the entrance to a walled city

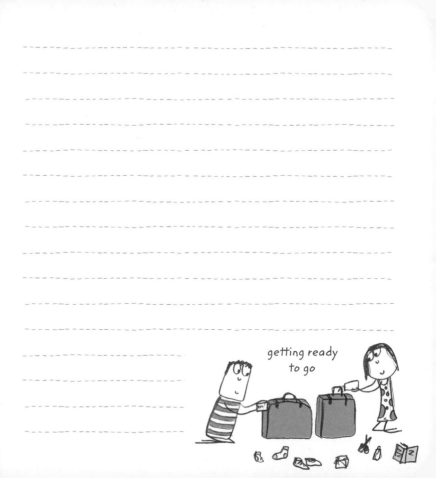

getting ready
to go

the freedom to go
anywhere

sampling local flavors

New York City

having friends to
explore with

buying gifts to
bring home

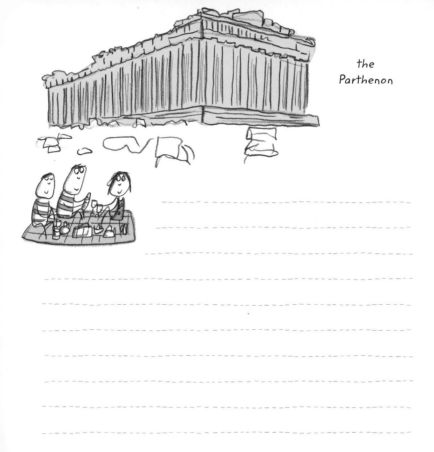

the
Parthenon

traveling with a
surfboard

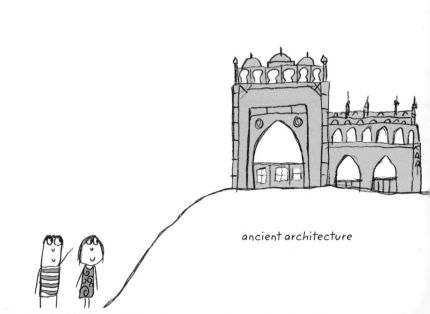

ancient architecture

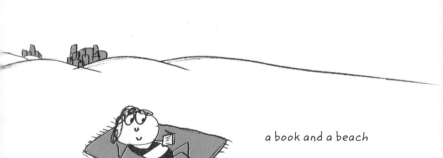

a book and a beach

riding a camel

finding space

an epic train ride

meeting new friends
en route

traveling the world
with a backpack and
a toothbrush

uploading photos
after a trip